GREAT FANTASY
ART THEMES
FROM

THE FRANK
COLLECTION

JANE & HOWARD FRANK

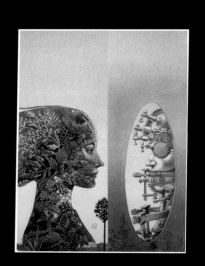
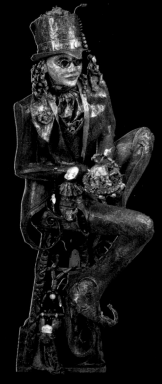
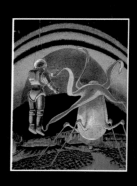
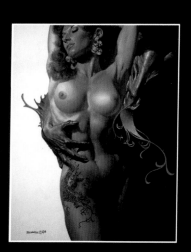

GREAT FANTASY ART THEMES FROM

THE FRANK COLLECTION

JANE & HOWARD FRANK

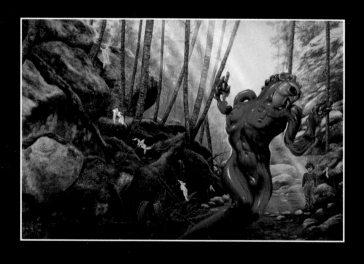
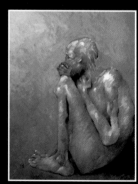
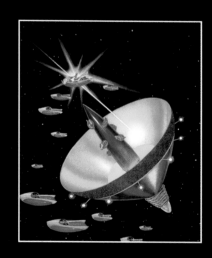

Paper Tiger

Illustrations on previous page, from left to right:
Leo and Diane Dillon: **Coming To Our Senses: Body and Spirit in the Hidden History of the West** (see page 41)
Lisa Snellings-Clark: **No refunds, No Returns** (see page 122)
Frank R. Paul: **Life on Saturn** (see page 12)
Boris Vellejo: **Dragon Prince** (see page 86)
Jim Burns: **The Fetch** (see page 95)
Jeff Jones: **Bogman** (see page 91)
Malcolm Smith: **The Friendly Killers** (see page 47)

First published in Great Britain in 2003 by Paper Tiger
an imprint of Collins & Brown Limited
64 Brewery Road, London, N7 9NT
www.papertiger.co.uk

Distributed in the United States and Canada by Sterling Publishing Co,
387 Park Avenue South, New York, NY 10016, USA

9 8 7 6 5 4 3 2 1

British Library Cataloguing-in-Publication Data:
A catalogue record for this book is available from the British Library.

ISBN 1-84340-073-1
Commissioning Editor: Paul Barnett
Designer: Malcolm Couch

Reproduction by Bright Arts Pte, Singapore
Printed and bound by Kyodo Pte Ltd, Singapore

ACKNOWLEDGEMENTS

We would like to thank Malcolm Couch, Colin Ziegler, Nicola Hodgson and especially our tireless editor, Paul Barnett – who made this book possible. Our thanks also to our indefatigable photographer, Greg Staley, who worked conscientiously to make sure all the transparencies were "just right". And our fond encouragement to the next generation of fantasy art fans, our grandchildren Douglas, Jennifer and newest addition Eve – who we hope will get great pleasure from this book when they grow up! And, last but not least, our thanks to all the fantastically talented artists who have made our collection – and this book – possible. It's been our pleasure to have your art on our walls! *JF, HF*

CONTENTS

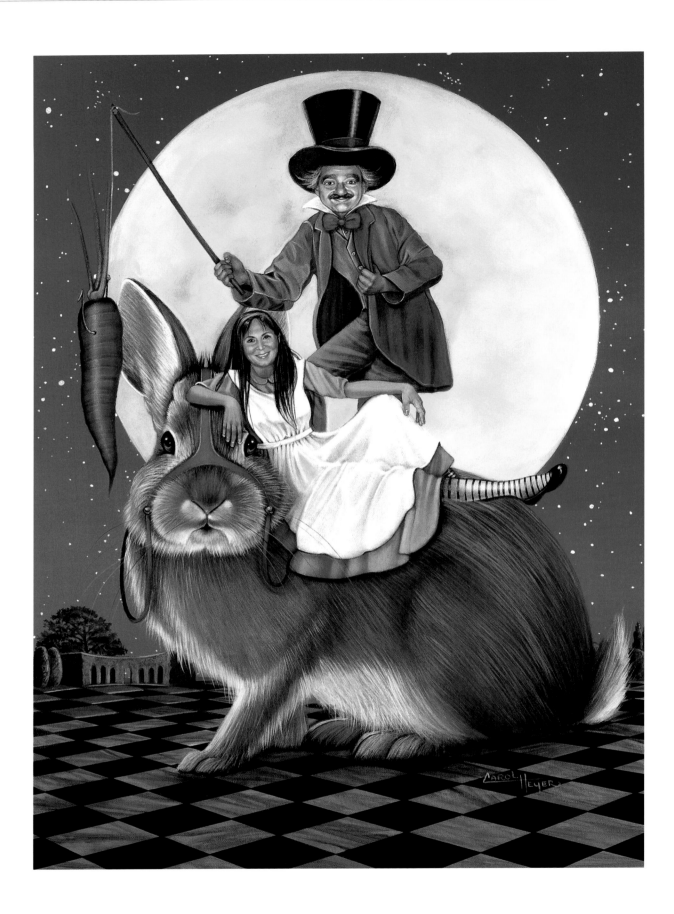

INTRODUCTION

FREQUENTLY ASKED QUESTIONS

OVER THE YEARS we've been asked many questions about The Frank Collection. Friends are curious as to why we have amassed so many paintings, and how we decided to collect this sort of art to begin with. Our children secretly want to know if we will ever stop, and what we're going to do with all these pictures one day. Beginning collectors touring the collection ask how we decide which pieces to buy and how much to pay for them. Strangers unable to fathom the appeal wonder what it's like to live with such an overabundance of visual stimulation, and thus ask questions like 'Which one is your favourite?' – as if we could have four hundred paintings on the wall and only *one* favourite! People with 'normal' mainstream tastes even ask us, 'Is it art?' Occasionally a visitor turned off by these images will ask: 'What attracts you about this art?'

Perhaps the most surprising (to us) but most repeated query is: 'How do you sleep at night?'

Our answers, while always satisfactory to us, rarely settle the matter for the questioner. But, just for the record, we're going to try again!

'What attracts you to this art?'

Because it is beautiful, thrilling, gives us a lift, and is always a pleasure to look at. Because its creators are able to visualize what doesn't exist and then translate that vision into finely crafted images. Because there is always something new to find in each painting, and because, once found, the original freshness of the first viewing can be found again. And because, at 4am in a quiet house on a dark night, what better thing could one do than look at these wonderful images and be uplifted by, simultaneously, their simplicity and their depth.

'How do you decide what to buy?'

The first and primary rule is that we buy what appeals to us. For most paintings, the appeal is immediate and jumps out at us both. Sometimes, only one of us sees it and feels strongly about it, and the other goes along, having trust in the merit of the first's instincts. If one of us balks, that's a good reason for a discussion. There's always a good reason for deciding *not* to buy. We never regret our decisions, one way or another. We have never had a case of buyer's remorse.

Facing page:
Carol Heyer: ***Jane and the Mad Hatter***
Private commission, 1999
Acrylics on canvas
24in x 19in (61cm x 48cm)
Reproduced by kind permission of the artist.

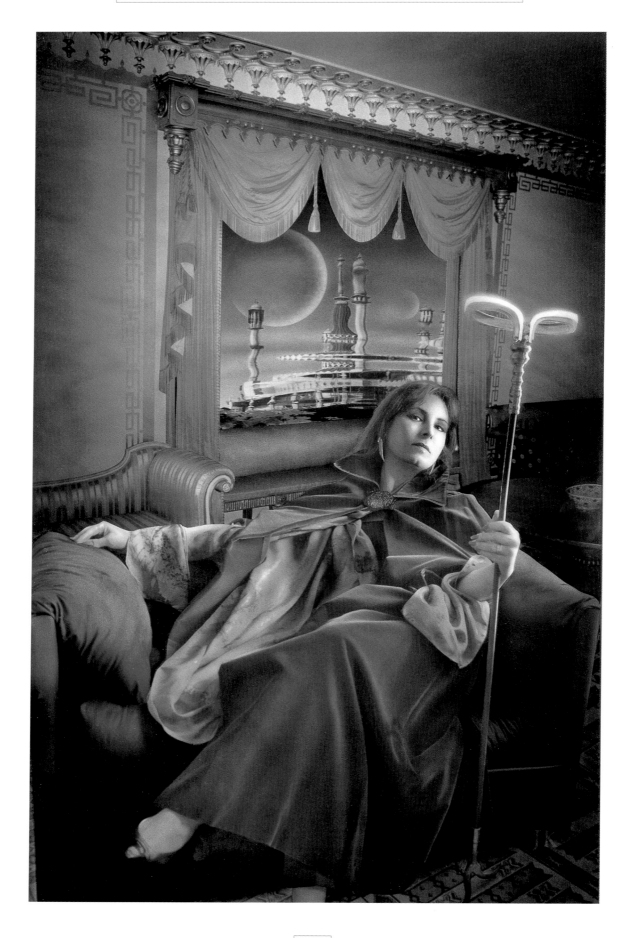

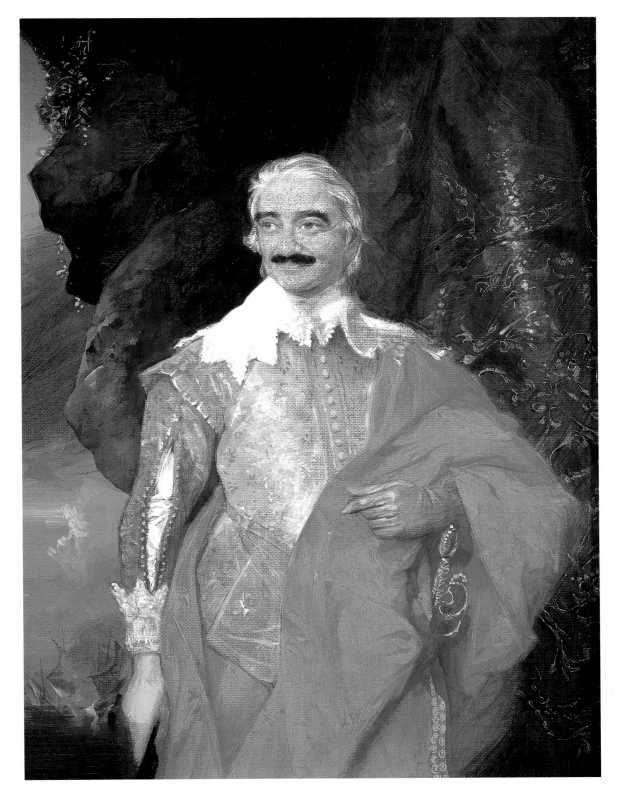

Left:
J.K. Potter: **Portrait of Jane**
Private commission, 1992
Hand-tinted photo-collage
20in x 12.5in (51cm x 32cm)
*Reproduced by kind permission of
The Frank Collection.*

Above:
Richard Bober: **Portrait of Howard**
Private commission, 2002
Oils on canvas
10in x 8in (25cm x 20cm)
Reproduced by kind permission of the artist.

CHAPTER 2

ONWARD TO GLORY!

CONQUERING UNKNOWN universes and mapping uncharted territories of the imagination – these stirring themes of adventure lie at the heart of much sf and fantasy, and thus are naturally important in our collection. Space marines, Roman soldiers, armoured knights, brutal monsters, legions marching to battle, warrior dragons, muscular barbarians, the Fellowship of the Rings, lost worlds and ravenous dinosaurs! Paintings with these elements consume a fair amount of wall space – and every square inch is sure to be colourful.

J. Allen St John's classically romantic knights (below) were

Below:
J. Allen St John: ***In Shining Armor***
Cover for vol. 11 of the My Book House for Children series edited by Olive B. Miller *c*1932-7)
Oils on canvas
25in x 23in (64cm x 58cm)
Reproduced by kind permission of The Frank Collection.

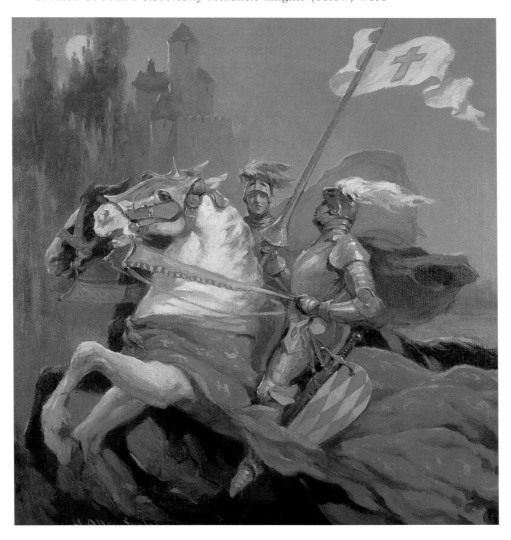

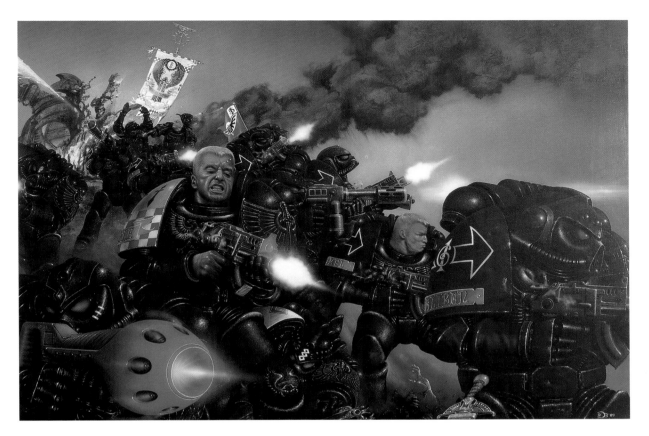

painted for the cover for a children's book, *In Shining Armor.*
The book was one of a highly popular series, *My Book House*,
published in the 1930s, and is a rather curious anthology. It
collects pieces such as 'The Bugle Song' by Tennyson, extracts
from *Don Quixote*, Dante's *Inferno*, Richard Wagner,
Shakespeare and Washington Irving, part of a speech ('Your
America') by Woodrow Wilson and Lincoln's Gettysburg Address.
That this strange combination worked is evidenced by the fact
that the two copies in our library were published one in 1937
and the other, a reprint, in 1963! We cannot help but feel that
St John's cover painting instilled in generations of children the
romantic idealism needed to appreciate historical masterpieces
of literature.

A very different sort of historical fiction is implied by
Valigursky's dramatic *Worlds of the Imperium* (right). This illus-
tration graced the cover of a 1962 Ace Double by Keith Laumer
that advertised: 'His deadliest foe was his own Alternate World
self.' But, even without an explanatory blurb, professional sf
illustrators would often provide subtle clues to readers, as here:
the tiny planet Saturn in the sky gives away the true nature of
this tale. Another (quasi)reality is shown in Jim Burns's painting
Space Marines (above), and more overtly; the future rather than
our past is the focus here, but a future where armoured
warriors *still* stand between us and the bad guys.

These three paintings, painted decades apart by artists
influenced by differing aesthetic sensibilities, illustrate adven-
tures in three separate eras. St John portrays, in 'golden age'

Above:
Jim Burns: **Space Marine**
Adventure-game cover (Games
Workshop, 1989)
Acrylics on illustration board
18in x 26in (46cm x 66cm)
*Reproduced by kind permission of
the artist.*

Facing page:
Edward Valigursky: **Worlds
of the Imperium**
Cover for the novel by Keith
Laumer (Ace Double, 1962)
Oils on illustration board
20in x 12in (51cm x 31cm)
*Reproduced by kind permission of
the artist.*

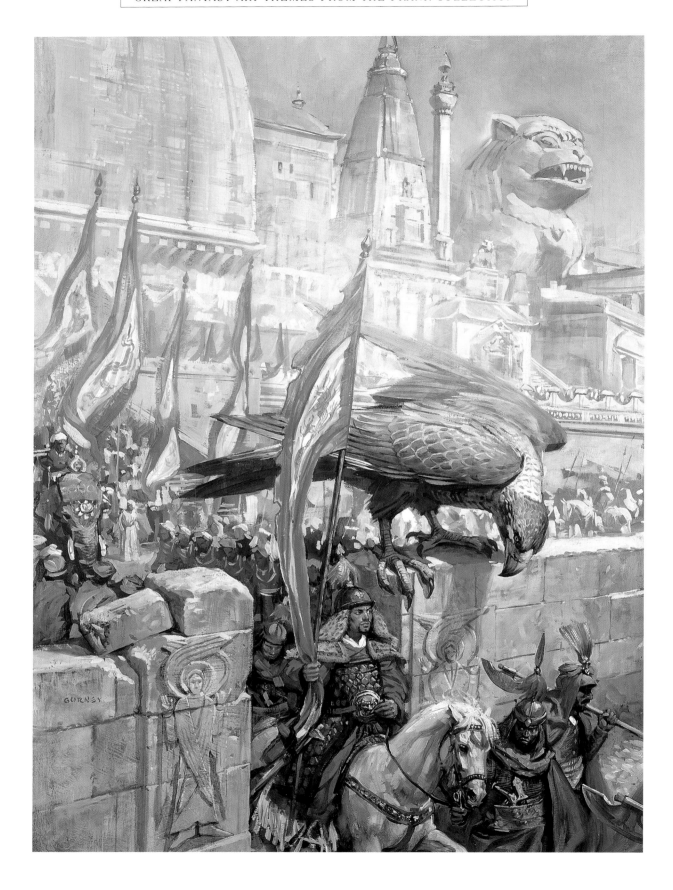

Brandywine School manner, an artistry perfectly suited to classical Middle-Ages escapades. The second, by Valigursky, shows us a more modern style of painting, moving away from a more 'painterly' to a more realistic technique, one perhaps better suited to the depiction of an alternate world where history took a different turn. The third, by Burns, was created for a contemporary and popular epic space-adventure game. Superficially the paintings may seem very different. But all contain metal-sheathed, confident soldiers equipped for battle. Styles have evolved, armour has become more capable and the weapons are deadlier, but the thrill of the adventure is constant.

Speaking of preparing for battle, note the finely wrought, classically rendered medieval armies of James Gurney's *Realms of the Gods* (facing page) and Roy Krenkel's *Road to Asrael* (page 30). Can there be any doubt that all of these brave soldiers will be victorious?

Above:
Tom Barber: **Zarg**
Unpublished, 1977
Oils on canvas
18in x 17.5in (46cm x 44cm)
Reproduced by kind permission of the artist.

Facing page:
James Gurney: **Realms of the Gods**
Cover for the novel by Catherine Cooke (Putnam/Berkley, 1988)
Oils on masonite
21.5in x 15.25in (55cm x 39cm)
Reproduced by kind permission of the artist.

Jeff Jones:
The Undying Wizard
Cover for the novel by
Andrew Offutt (Zebra,
1976)
Oils on canvas
22in x 18in (56cm x 46cm)
*Reproduced by kind permission
of the artist.*

Gary Ruddell: **Sugar Rain**
Cover for the novel by Paul
Park (Avon, 1989); republished
as cover for *Realms of Fantasy*,
June 2000
Oils on canvas mounted on
masonite
23.5in x 14in (60cm x 36cm)
*Reproduced by kind permission of
the artist.*

the disembodied head and amputated arms of a man whose
mouth was opened in a perpetual scream – for the rather more
modest price of $300. It goes to show that paintings of
dangerous ladies obviously have much higher market value to
collectors than illustrations of dead guys.

Fortunately, since then we've had the opportunity to add
several other McCauleys to our collection, and now own six.
McCauley (1913-1983) was one of the stalwart illustrators of
the pulp era, working for magazines such as *Amazing, Fantastic*

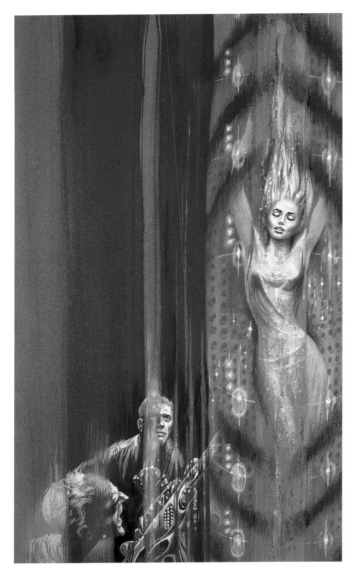

Above:
Ed Emshwiller: **The End of Eternity**
Cover for the novel by Isaac Asimov
(Fawcett/Crest, 1955)
Acrylics on illustration board
19.25in x 11.5in (49cm x 29cm)
*Reproduced by kind permission of
Carol Emshwiller.*

Right:
Jim Burns: **Artificial Things**
Cover art for novel by Karen Joy
Fowler (Bantam, 1992; painted
1989)
Acrylics on illustration board
19.25in x 17in (49cm x 43cm)
*Reproduced by kind permission of
the artist.*

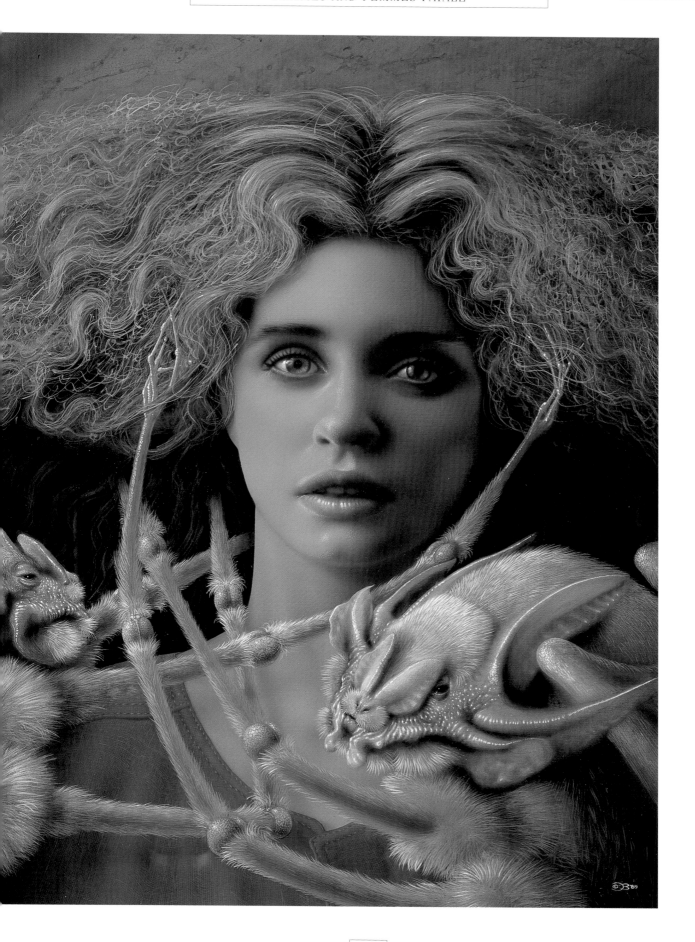

Facing page:
Leo and Diane Dillon:
Coming to our Senses: Body and Spirit in the Hidden History of the West
Cover for the book by Morris Berman (Bantam, 1989)
Acrylics, pastels and watercolours on illustration board
28in x 20in (71cm x 51cm)
Reproduced by kind permission of the artists.

Adventures, Imagination and *Imaginative Tales.* He was famous for his attractive women, called 'Mac Girls'. We've chosen three for this book.

All were covers for 1950s magazines. The first, *No Time for Toffee* (page 34), illustrated a story in the popular series by Charles F. Myers. Toffee was the rollicking, tongue-in-cheek, sexy heroine with 'impertinent manner, perfect figure, and scandalous conduct'. ('Marc had a problem: If assassins didn't kill him – Toffee would love him to death!' is the one-line description on the July 1952 *Imagination* Contents page.) The second, *The Eye of the Temptress* (page 34), illustrated a 1951 *Other Worlds* story by Rog Philips and is another eye-catching (ahem) example of McCauley's splendid work.

Planet of Dread (page 35) illustrated a swashbuckling story by Dwight Swain. The story involves the nasty 'dark vision of sinister beauty, "Vydys"' and her victim, a lovely maid from Baemae sent to meet her doom in a walled coliseum-like ring. This maid was a pistol-packing, whip-toting, red-leather-bikinied blonde-haired babe – the perfect Mac Girl and the perfect 1950s magazine cover! We imagine readers ripping these books right off the racks as soon as they were delivered. We certainly leapt at the chance to acquire the painting.

Not all femmes need to be sexy or deadly to find a spot in our collection. The rather demure space-helmeted lady in bra and short skirt by Leslie Ross, which we call *Feather Girl* (page 34), appeared on issue #1 of *Dynamic Science Fiction* in 1952, illustrating the story 'Blood Lands'. We find it charming and indicative of what we now think of as simpler times, when feathers, space helmets and two-piece bathing suits coexisted without complaint.

Quite different sorts of ladies include the three-faced beauty of Jim Warren's *Welcome to America* (page 36) and the likely Archimboldo-inspired female in Leo and Diane Dillon's *Coming to Our Senses* (right).

Our collection contains a breadth of images and styles – figurative, narrative, semi-impressionistic and surreal. We are not drawn to particular styles of painting but rather to the way images are rendered and treated. Thus a weird-looking landscape can be just as enchanting as a ravishing woman. The stark beauty in Gary Ruddell's *Sugar Rain* (page 37) is just as compelling as the lovely creature in Emsh's *End of Eternity* (page 38) or the lady in Jim Burns's painting *Artificial Things* – who is downright gorgeous, even given her choice of pets.

Many genres of illustration depict girls, ladies and women, but only sf and fantasy have pictured femmes with such wit, energy, variety and imagination – from short to tall, beautiful to strange, human to alien. These femmes are the greatest. Long shall they rule!

images conjure up more directly personal catastrophes. Alex Schomburg used a personal touch to show how space is a lonely, empty place in his 1958 painting of a long-dead astronaut stranded in space, *Final Fate* (page 49), poignantly capturing the loneliness of such a solitary death. Bear in mind, our future in space at that time was still bright and sunny; the *Challenger* disaster was far in the future.

At the end of the voyage not all is bleak; there are the wonders of strange lands, mystical cities and eerie landscapes. Behold the pristine beauty of Tim White's vision in *Foundation and Empire* (page 52-3) or try to see the universe through the surreal looking-glass of Richard Powers's *Neutron Stars* (above). What wonders, what horrors and what thrills lie beyond what we can see? That mystery may be at the heart of what attracts us to space art.

Richard Powers: **Neutron Stars**
Cover for the novel by Gregory
Gerald (Fawcett, 1977)
Acrylics on wooden door panel
30in x 30in (76cm x 76cm)
*Reproduced by kind permission of
the Estate of Richard Powers.*

Tim White:
Foundation and Empire
Cover for the novel by Isaac
Asimov (Grafton, 1983)
Gouache on illustration board
12in x 16in (31cm x 41cm)
*Reproduced by kind permission
of the artist.*

reversal after reversal – his cats destroyed a first attempt, another accident ripped the canvas of a second one, and at the end he could not bring himself to complete the painting as rendered in the sketch; he felt compelled to produce one double the size we had contracted for and which then wouldn't fit on the wall! Artist's block then hampered the completion of a final effort, but – miraculously – after four years we finally took delivery of a painting.

We've been at the project now for four years and we've decided to complete it with the commissioned works appearing in this chapter. The results have been wonderful and absolutely gratifying. Each artist has created a truly memorable work, technically masterful and artistically superb. They are: *Cleopatra* by Richard Bober, *The Ancient Allan* by Bob Eggleton, *King Solomon's Mines* by Don Maitz, *Pearl Maiden* by Gary Ruddell, *The World's Desire* (co-authored with Haggard by Andrew Lang) by Jeff Jones, *The Brethren* by Ian Miller, *Eric Brighteyes* by Donato Giancola, *Nada the Lily* by Stephen Hickman and *She* by Michael Whelan.

Each of these paintings, of course, has a special story behind it. The normal way we commission a painting is to first discuss the general concept of the project. The artist then

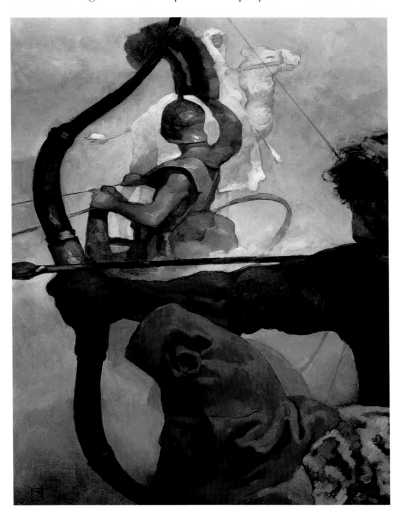

Jeff Jones: ***The World's Desire***
Oils on canvas
32in x 24in (81cm x 61cm)
Reproduced by kind permission of the artist.

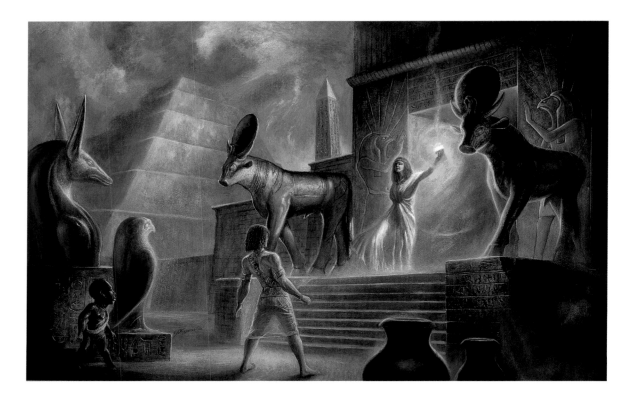

Bob Eggleton: **Ancient Allan**
1999
Oils on canvas
26in x 40in (66cm x 102cm)
Reproduced by kind permission of the artist.

produces one or two simple black-and-white concept sketches. We next discuss the approximate size of the piece and, based on the painting's size and complexity, agree on an approximate price and time-frame for delivery. The artist may produce a somewhat more detailed colour rough. We then finalize price and delivery details and give the formal go-ahead for the commission.

That's our usual method. But hardly any of the paintings for the Haggard Project were completed by the usual method! One artist was halfway through the finished painting before we even understood that he had agreed to do it. We never saw a sketch, had no idea of its size and no plan for any delivery – since we had never discussed it. 'If you don't like it, don't pay me,' was how this commission was negotiated. When the painting arrived, within a few months, we were delighted.

With another artist, Howard requested sketch after sketch after sketch. Somehow, even though he was willing and eager, the artist was missing one of the main points of the project – to go beyond normal illustration boundaries. Finally Howard went through a stack of photographs of the artist's other works and found several that he had painted 'for himself' in a somewhat different style. 'Paint it like those' was the new instruction. Three wonderful new sketches arrived a few days later. We selected one and, a few months thereafter, had a Haggard painting that both we and the artist loved. 'Even my mother liked it,' the artist reported.

'Thanks for giving me a great idea,' was the comment of another. 'Now I think I'll paint it, whether you want me to or not.' After another month we heard: 'The painting is going to be

[this] big, you'll get it when you get it, I'll let you know the price when I let you know the price, and if you like it you can buy it. If you don't, I'm confident someone else will.' As you might suppose, we *loved* this variation of our normal commissioning mode!

One artist read the book and started to paint, and just painted until he was done. Another, Bob Eggleton, read the book and just kept on reading! He read histories of the time period, he did research into the costumes, he studied pictures of artifacts and antiquities held by museums. By the time he had finished the painting, he knew more about the book's background and themes than we did! Assigned the painting for *The Ancient Allan* (left), Bob found that

> This offbeat story in the Allan Quatermain saga was not what one would expect. Basically it is a tale that takes place in another timeline, in another age with quite literally, an ancient Egyptian 'Allan'.
>
> The visual prospects are indeed rich, given the backdrop. However, because it happened in an early age of Egypt, things were a lot harder to find reference for. The hardest were those Apis Bulls standing either side of the temple. I looked in many books, as did my wife Marianne [Plumridge], who did some incredible research and costume-making for this piece. We even went to Las Vegas and stayed in the Luxor Hotel, with its Egyptian motifs, to get an idea of the feel I needed. At an exhibit entitled 'Pharaohs of the Sun' in Boston, on a shelf in the gift area, was a resin replica of the elusive Apis Bull. To get the lighting and perspective just right, it was like finding a treasure. Going about painting the picture, I wanted a Turneresque feel to the colours, so it was a lot of fun to paint in the end, after going through so much research work.

In several instances we had trouble deciding which sketch to take to a final painting because they were all so good. We wanted them *all* – we wanted to see them all in final form even though we had room on the wall for just one by each artist. In one case, *Eric Brighteyes*, we just gave up and said, 'Go ahead and paint the second painting. The painting deserves to exist and we can't let it not be painted.' What was even more unusual about this decision was that the first painting turned out to be a triptych (page 64) and the second, *Eric and Skallagrim* (page 65), was an alternative to the centre panel, so by strict counting there are actually *four* paintings! The artist responsible for these wonderful artworks, Donato Giancola, explained to us the inspiration behind the works:

> The novel *Eric Brighteyes* is rich with visual imagery of landscapes, grand conflict and passion. To illustrate the epic exploits in the book I chose an allegorical representation rather than a direct narrative treatment. The love triangle

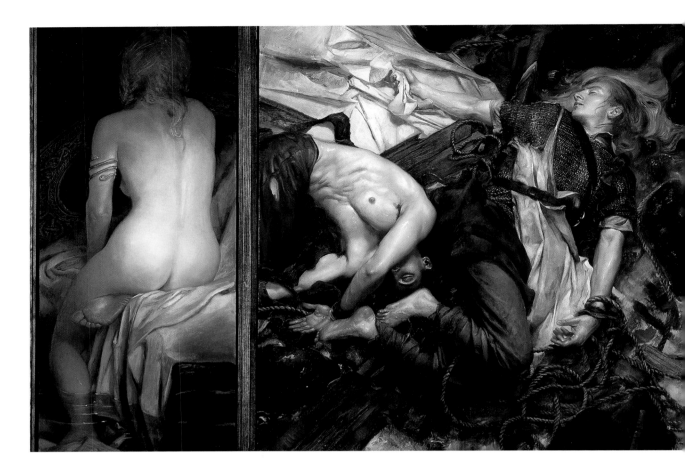

Donato Giancola: ***Eric Brighteyes***
2001
Oils on paper mounted on masonite
Triptych 34in x 68in (86cm x 173cm)
*Reproduced by kind permission of
the artist.*

between the main characters – Eric, Gudruda and Swanhild – suggested that a triptych was the optimum solution. Eric, as the centre of the story, is also the centre of the triptych. Chaos surrounds Eric in this panel, representing the disruption he wreaks in the lives of his two lovers and friends. The three panels, physically separate from each other but linked by elements of compositional similarities, parallel the dance the characters are bound in as they meet for fleeting moments in the story, only to be torn apart a few pages later. The pursuit of Eric's sexual and social validation, and their unattainable resolutions, are the driving force of unity and tension within both the story and this triptych.

When one artist said, 'It will be done in a year's time, in April,' we were content to take his word for it, and by March we were making plans for where it would go on the wall. When April had come and gone and the artist said, 'I've been swamped by work … for sure by Christmas,' we said: 'Ah, we understand. These things happen.' When Christmas passed, he was apologetic and said, 'Something came up. It will need to be February or March.' Then Spring rolled around again and June became the target month. When the artist said, 'Just give me until the Fall,' we thought to ourselves, 'This will never happen.'

After two years, he said, 'The painting is ready and I could

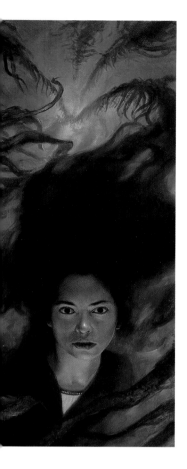

Donato Giancola: ***Eric and Skallagrim***
2002
Oils on paper mounted on masonite
34in x 36in (86cm x 91cm)
Reproduced by kind permission of the artist.

deliver it now, but can I exhibit it once in public, at a fantasy convention?' How could we refuse? 'The convention is in January,' he added, 'and I will personally deliver it to you by the end of the month, right after the show.' By mid-February the painting had still not been delivered and 'I just had to make a few slight last-minute changes,' he said, not at all abashed. 'Yes, I put it on display, but I wasn't one hundred per cent satisfied with it,' he confessed, 'and, knowing you would want only the best from me, I just had to make those changes.'

When the artist finally walked in through our door with the painting, all sins were forgiven. The painting was spectacular, we forgot the wait, and in retrospect we can't imagine how anything different might have been done.

Ian Miller probably speaks for a great many artists when he says, 'Everything is driven by mood.' We chose Ian to illustrate *The Brethren* (page 66) – a medieval story of the exploits of two warrior cousins during the times of the Crusades – because of his unique style. We expected Ian would produce a very special work, and we were not disappointed!

The nature of this commission required a modicum of research beyond the actual reading of the story. Observational drawings made by scholars of the period in Constantinople provided me with excellent reference material for both the Christian Knights and the Saracen

Ian Miller: ***The Brethren***
2001
Acrylics and inks on
illustration board
16.5in x 25.25in
(42cm x 64cm)
*Reproduced by kind permission
of the artist.*

soldiers. It was very interesting to discover how
the garb, armour and weaponry of the Saracens differed
so much from the standard movie perceptions. Straight
swords were very much the thing, with little evidence of
the curved scimitar-type blade. People knowledgeable in
this field would probably say 'Why, yes, of course, blah
blah,' but it was a perceptual rework for me. Beginning
this very busy and congested piece was nothing

short of daunting, but I started anyway with a series of
rough drawings to establish how the finished piece would
look. This is the norm, of course. From these I was able to
lay down the structure of the finished image in pencil line.
What mattered most during this first stage was to establish
a dynamic in the overall image that embraced movement,
mood and most especially an appreciation of the author's
original vision. Everything is driven by mood. No matter how

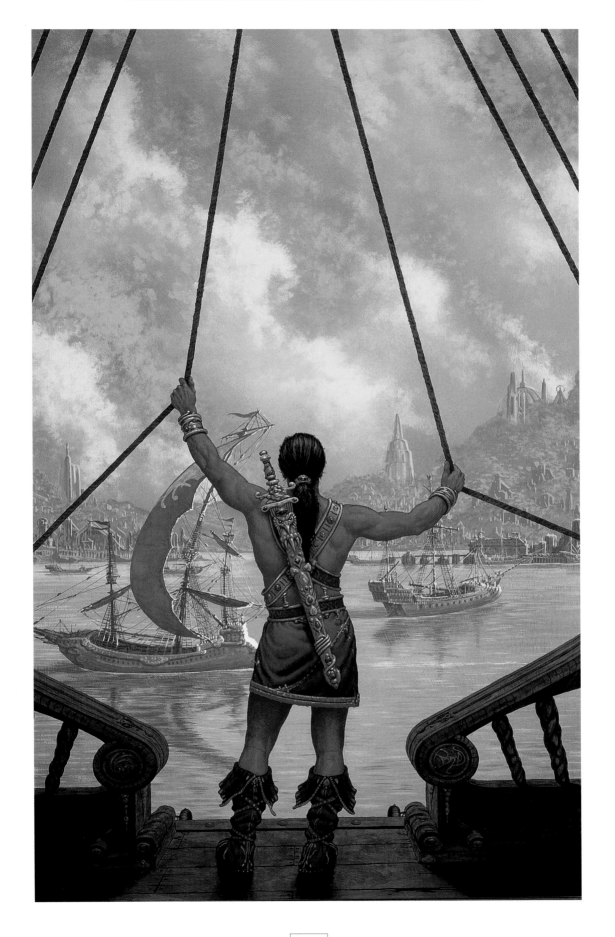

Above:
Ken Barr: **Huon of the Horn**
Cover for the novel by Andre Norton
(Fawcett, 1979)
Oils on illustration board
28in x 20in (71cm x 51cm)
*Reproduced by kind permission of
the artist.*

Facing page:
Gary Ruddell: **Thieves' World**
Cover for the anthology edited by
Robert Lynn Asprin and Lynn Abbey
(Ace, 1979)
Oils on canvas on panel
21in x 15in (53cm x 38cm)
*Reproduced by kind permission of
the artist.*

Kane, actually the first of Robert E. Howard's heroes, initially saw print in 'Red Shadows' in the August 1928 issue of *Weird Tales*, which promised 'Thrilling adventures and blood-freezing perils – red shadows on black trails – savage witchcraft and the Black God'. But after several stories Kane was dropped in favour of a new hero, Conan, and so was relatively unknown until Donald Grant – and Jeff Jones, as his illustrator of choice – helped bring Solomon Kane stories to a new generation of readers. In various stories the author described Kane as 'a tall, gaunt man' with 'long, swinging strides' and 'darkly pallid face and deep brooding eyes'. We think Jeff Jones has captured this fabulous swashbuckler to perfection in his painting *Solomon Kane* (page 76).

Romas (Kukalis) and Ken Barr chose to depict their heroes in somewhat different form. In Romas's painting *The Destiny of the Sword* (page 77) the brave fellow, his back to the viewer, looks at a serene harbour scene – which looks familiar enough for it to be a scene from ancient history, but yet has definite hints of an exotic locale, replete with sword and armour and the military posture of the adventurer. The painting was actually commissioned for the cover of the third book in a series about a modern earthman transferred into the body of a man on an alien planet. But that kind of information is not needed to enjoy the painting as pure escape into 'heroic' times.

Ken Barr's hero, Huon – depicted in his *Huon of the Horn* (above) – also faces away from us. Good thing, too, because his danger is not so subtle! A monstrous, evil and clearly hungry snake-to-end-all-snakes is about to take lunch, but – thanks to Huon – only with some effort. We own few other paintings that use Romas's and Barr's tactic of placing the hero facing away from the viewer, although it is a familiar pose. In the hands of professionals, this technique is very effective at drawing the viewer into the painting. And these two were so well implemented we knew we had to have them the very first time we saw them!

At quite the opposite end of the spectrum, in terms of mechanisms for depicting heroes, there's Gary Ruddell's compositionally dynamic approach, demonstrated most ably in his many illustrations for the popular *Thieves' World* adventures. This lawless world, created by Robert Lynn Asprin, was based in Sanctuary, a city of outlaws and adventurers, and Ruddell's cover for the first book in the series (facing page) is especially effective. The painting is a powerful reminder that good looks are not necessarily the key to victory.

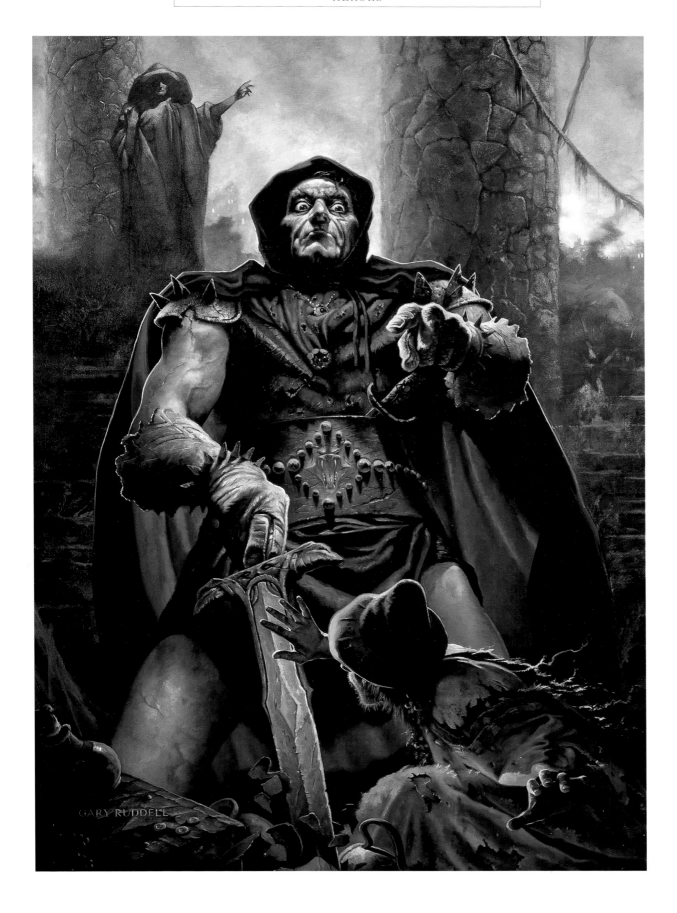

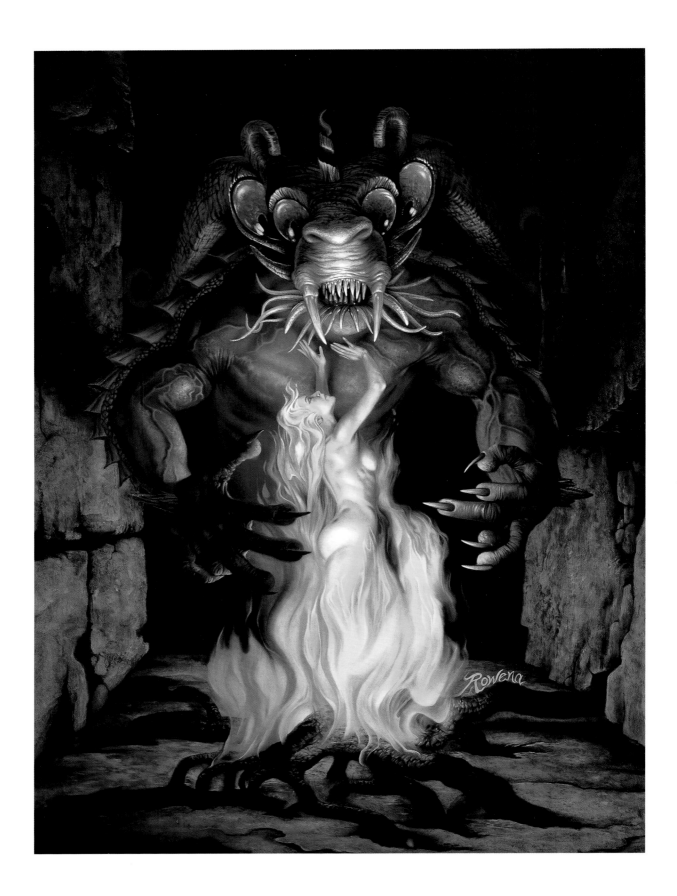

CHAPTER 7

FOR MATURE AUDIENCES ONLY

IN FANTASY ART, certain elements invariably go together: barbarians and outsized muscles, swords and sorcery, wizards and elves. Another regular pairing is semi-clad or naked ladies and monsters. These damsels are not always in distress.

The ladies tend to be rather standard: curvaceous blondes and redheads are preferred. The monsters, on the other hand, come in a wide variety of shapes and sizes, some of them violent creatures seeking to ravage, others acting more like pets. The ladies of sexy fantasy paintings rarely appear solo, as do pinups, and usually have props like swords, whips and rayguns.

Nowadays, published fantasy illustrations with overt sexual elements are rare. Where once it might have been possible, if not enthusiastically accepted, to show bare breasts and rather overt sexually fantastic scenes on the covers of popular and widely distributed books and pulp magazines (for example, Margaret Brundage's *Weird Tales* in the 1930s), such imagery is now considered *verboten*. Publishing has become more puritanical with time, and even the naive sexual innuendoes of the kind frequently seen on paperbacks and magazines in the 1950s are almost entirely gone – or the paintings have been 'adjusted' for publication by covering up anything that might titillate an adolescent.

A fine example of an entertaining twosome is Rowena's *Night Demon and Fire Girl* (facing page). The artist's technique here is flawless, as usual; she has few peers when it comes to portraying the female human form. The Night Demon monster in this case is warming his hands at a cozy cave fire with the Fire Girl rising, dreamlike, in the midst of that convenient fire – convenient in that it makes a strategic prop for covering obvious female anatomy.

Teasing of this sort is also found in other provocative paintings on our walls, including one by Kelly Freas for John Norman's *Marauders of Gor* (page 82). See how carefully those bear claws have been placed! For those unfamiliar with the Gor stories, think sexy dames, mighty warriors, whips, chains and a bit of gore. Needless to say, Gor is a 'special' kind of world. It is not for the meek and definitely not for folks who believe in equality of the sexes. In the real world, pity the lady in this painting. In the world of Gor, save your pity for the bear!

Another image, painted by Ed Emshwiller (Emsh) for L. Sprague de Camp's *Rogue Queen* (page 83), provides a good

Facing page:
Rowena (Morrill): ***Night Demon and Fire Girl***
Trading card and box cover (FPG, 1994); republished in *The Art of Rowena* (Paper Tiger, 2001)
Oils on illustration board
22.5in x 16.5in (57cm x 42cm)
Reproduced by kind permission of the artist.

Frank Kelly Freas: **Marauders of Gor**
Cover for the novel by John Norman (DAW, 1975)
Acrylics on illustration board
18.25in x 13.25in (46cm x 34cm)
Reproduced by kind permission of the artist.

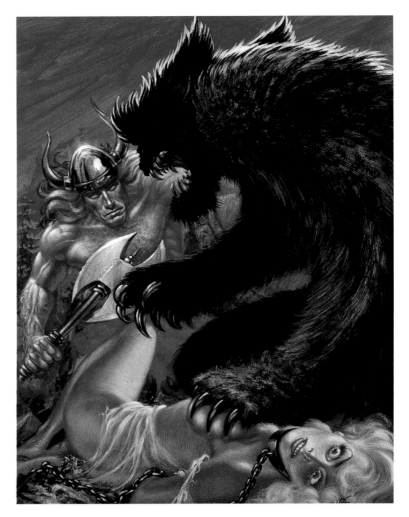

example of the more classic form of tease – a wonderful rendering of Iroedh of the Avtini community, replete with strategically placed forearm and gently windblown cloak. The Avtini are a hive-like community, and the story is about the 'awakening' of Iroedh under the stimulus of a group of visitors from outer space. Emsh's vision and interpretation of Iroedh is simultaneously sexy, exciting and charming.

We've been fortunate to have acquired a number of Boris Vallejo's sensuous paintings of women and mythical creatures in which, thankfully, little has been left to the imagination. Yet, thanks also to the artist's unfailingly refined artistic sensibilities, his paintings are always engaging and provocative, never crude. Boris's skills in painting the human form are unparalleled, and his ability to capture perfect bodies in interesting, fantastic environments is also extraordinary. We've chosen three to demonstrate the range of his talent for sensuality; they are also notable for having been included in his earliest art books. *Dragon Riders* (page 84) and *Spoor* (page 85) originally appeared in the marvellous book *Mirage* (1982), while *Dragon Prince* (page 86) was first published in a book of Doris Vallejo stories that Boris illustrated, *Enchantment* (1978).

Each painting offers something unique, some aspect of

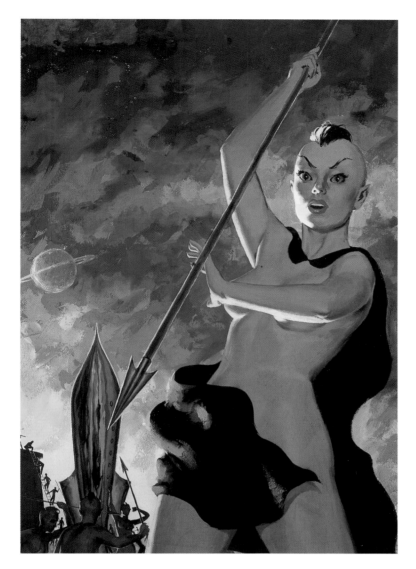

Ed Emshwiller: ***Rogue Queen***
Cover for the novel by L. Sprague
de Camp (Dell, 1951)
Acrylics on illustration board
13in x 9in (33cm x 23cm)
*Reproduced by kind permission of
Carol Emshwiller.*

composition that directs your thinking beyond the obvious refer-ences to sexuality. *Dragon Prince*, for example, takes its strength from contrasting an almost photo-realistic rendering of the female model with a clearly fantastical dragon. An engaging transition between the two forms takes place in the transfor-mation of the dragon's claw into a dragon tattoo on the woman's torso. *Spoor*, a rarity among sexually explicit paintings for its willingness to depict male anatomy, is also a study in contrasts, balancing its fantastic elements with classically beautiful figures.

More extreme and challenging depictions of bodies in unfamiliar poses can also be found on our walls. These are in the class of not-so-comfortable paintings, which we find visually appealing because they, just like all our favourite paintings, communicate something unusual about the world or about the artist who created them.

Tim White's *The Space Machine* (page 87), for example, is a rather troublesome piece, because we can think of better ways to employ these lovely bodies! But as illustration the painting

CHAPTER 8

WHERE EVIL LURKS

SOMETIMES it's difficult to explain how artworks get categorized into one theme or another, but with horror art there's rarely any confusion. In fact, although the reasons cannot easily be put into words, most people we've met seem to agree on what imagery they find disturbing or repulsive, even when they come from very different backgrounds and cultures. What they may not agree on is whether these images are of the sort that they'd want to live with on their walls.

Paintings with themes that remind you of your own nightmares, that take you to places you never want to visit or scare

Facing page:
Jael: ***Nightmare***
Personal work (1986)
Acrylics/oils on illustration board
25.75in x 16in (65cm x 41cm)
Reproduced by kind permission of the artist.

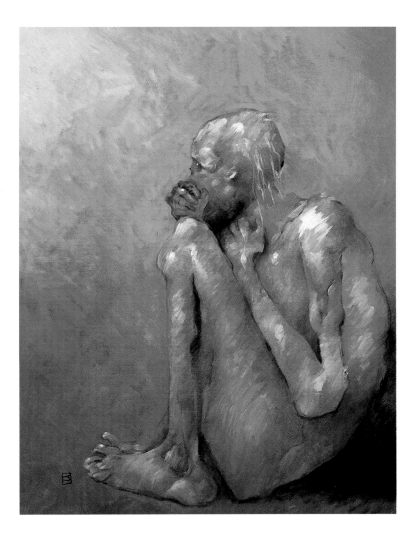

Left:
Jeff Jones: ***Bogman***
Back cover for *Taboo* (comic, Tundra Press, 1990)
Oils on canvas
15.5in x 11in (39cm x 28cm)
Reproduced by kind permission of the artist.

Right:
Rick Berry: ***Belling the Moon***
Back cover for the anthology *Still Dead*, edited by John Skipp and Craig Spector (Mark V. Zeising, 1992)
Oils on illustration board
30in x 20in (76cm x 51cm)
Reproduced by kind permission of the artist.

Facing page:
Todd Lockwood: ***Spell Rune Golem***
for *Ravenloft*™ game Creatures of the Night Copyright © by TSR™ Inc. (Wizards of the Coast, 1999)
Oils on illustration board
24in x 18in (61cm x 46cm)
Reproduced by permission.

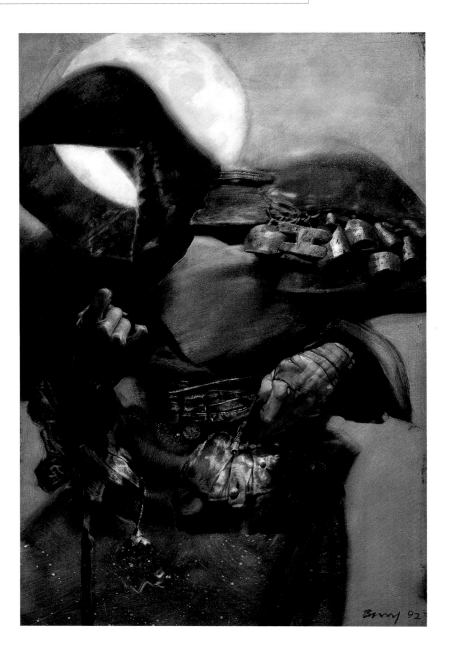

Above:
Don Maitz: ***Book of the New Sun***
Cover for the omnibus by Gene Wolfe (Science Fiction Book Club, 1998)
Oils on illustration board
30in x 20in (76cm x 51cm)
Reproduced by kind permission of the artist.

you to death are pretty standard fare for lovers of horror art. And we have our share of them. But what we look for – as hallmarks of quality – are those that approach these possibilities with a bit more energy, unconventionality and *savoir faire*.

Our Hall of Horror – so-named because the pieces displayed there are clearly classifiable as horror art – is not situated where the casual visitor will find it (although anyone wanting to go to Howard's office can't help but be exposed to a certain amount of blood and gore and some creatures and demons from Hell and other nasty places). But overcrowding in the Hall of Horror, our own desire to see some favourites more often, and the simple joy we derive from coming upon startling or disturbing art have meant that more subtle examples of the genre have migrated to libraries and rooms beyond the confines of the Hall.

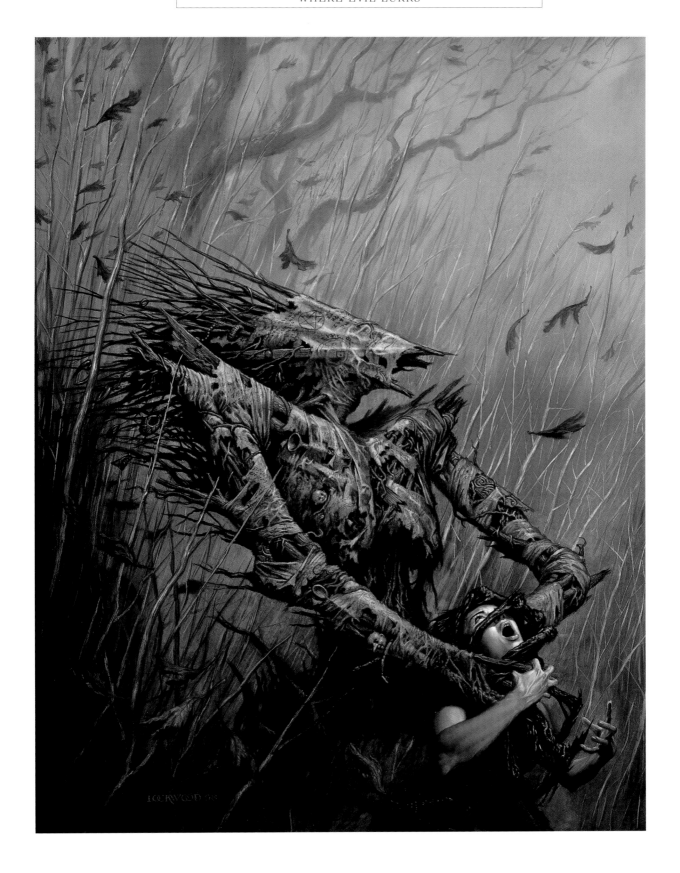

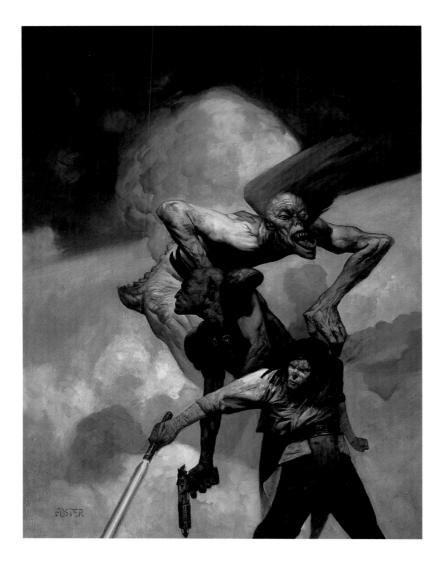

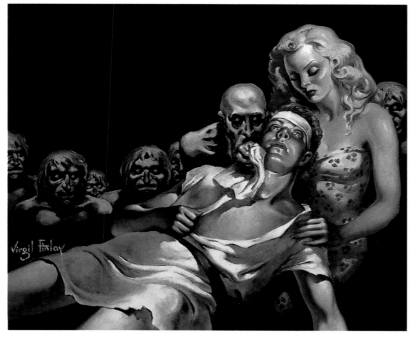

Above, left:
Jon Foster: **Anzati**
Cover for *Star Wars #35* (comic, Dark Horse, 2001)
Oils on canvas
40in x 30in (102cm x 76cm)
Reproduced by kind permission of the artist.

Left:
Virgil Finlay: **Darkness and Dawn**
Cover for *Famous Fantastic Mysteries*, vol. 2, no. 3, 1940, illustrating the novel by George Allen England
Oils on illustration board
14in x 12in (36cm x 31cm)
Reproduced by kind permission of Lail Finlay.

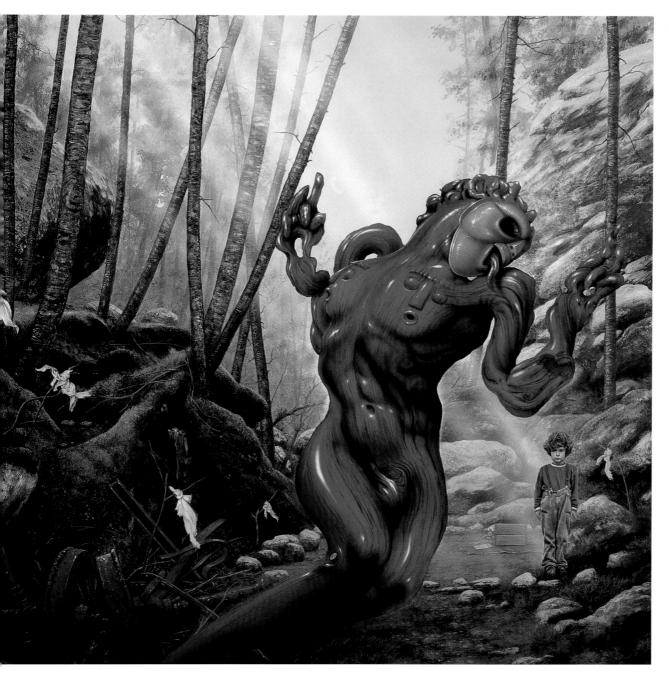

Jim Burns: **The Fetch**
Cover for the novel by Robert
Holdstock (Orbit, 1991)
Acrylic on illustration board
18in x 24in (46cm x 61cm)
*Reproduced by kind permission of
the artist.*

We must confess that perhaps we aren't the best judges of
what is subtle. We have accidentally liberated some truly
horrific images, or so we have been told. 'This is scary?' we say
in shocked disbelief: 'You can't mean it! Why, this is tame, this
is just interesting and fun.'

(A few years ago, our eight-year-old grandson Doug, while
bringing a friend to the house for the first time, took Howard
aside and whispered to him, 'Did you know you have scary
paintings here?' Howard answered, 'No, I didn't. Are you
scared?' Our grandson responded, after thinking it over for a
moment, 'No.' There ended any fear of the art.)

Speaking of fun, bad dreams make a particularly rich source

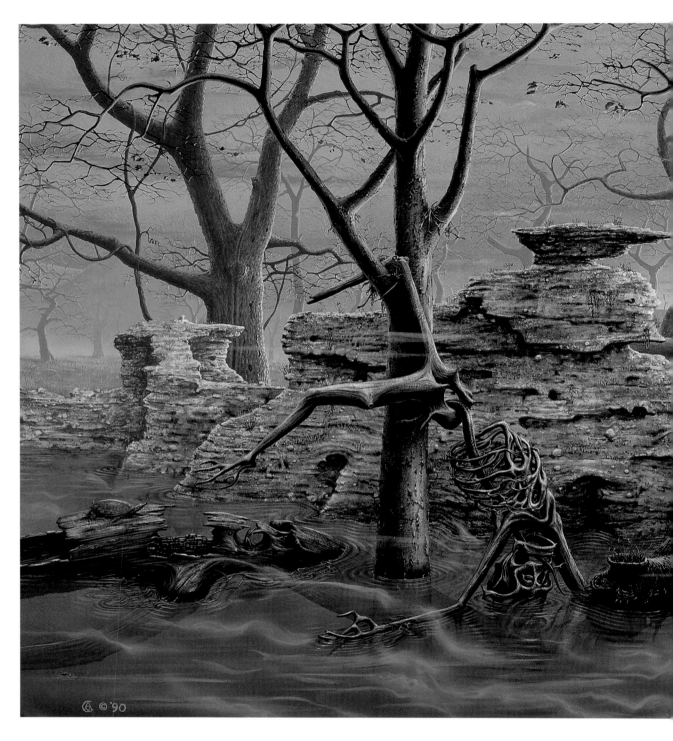

Alan M. Clark: ***The Sticks*** (1990)
Interior illustration from *Not
Broken, Not Belonging* by Randy Fox
and Alan M. Clark (Roadkill Press,
1994; painted 1990)
Acrylics on illustration board
22in x 27in (56cm x 69cm)
*Reproduced by kind permission of
the artist.*

of inspiration for artists. Few paintings are more explicitly
demonstrative of that demanding muse than Jael's *Nightmare*
(page 90). It unapologetically calls up one of a person's worst
fears, the desperate attempt to escape from whatever is in
pursuit. Other images depict the same need to escape but the
terror is psychological and the flight is to someplace within,
where no escape seems possible. No better example than Jeff
Jones's *Taboo* exists in our collection.

Evil's true identity can be hidden from us, as in Rick Berry's

Belling the Moon (page 92), or it can simply draw a mask and cloak of darkness about its visage, as in Don Maitz's *The Book of the New Sun* (page 92). There is something disturbing about vagueness, for what is not known seems always to be more disconcerting than what is; the blurry horror seen just out of the corner of the eye is what makes us shiver, not the terror plainly seen.

Then there are those straightforward depictions of horrific scenes – imagery which is supposed to provoke a gasp. The

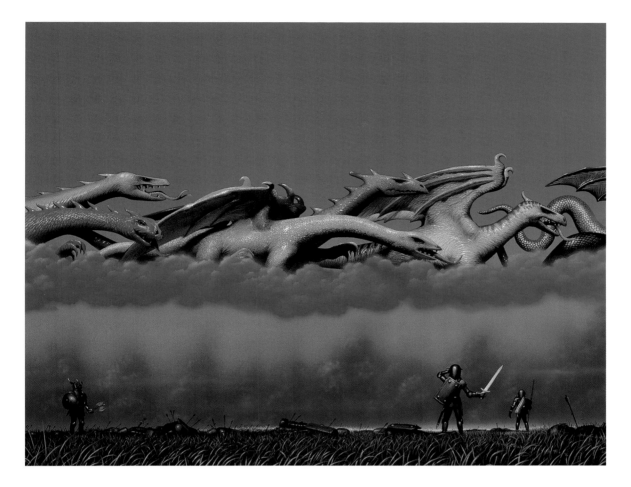

the look, impossible to equal, that will forever be associated with this magical series of books.

Both James Warhola and Richard Hescox bring a stylish modernism to their art, with an effective use of colour, a professional grasp of technique, and a dynamic handling of imaginary elements. Ugh, that sounds so arty, doesn't it? What we mean to say is: This stuff is fun! Look at those little guys holding up the book in *Sorcerer's Heir* (page 105). Look at the great dragon and characters in *Jason Cosmo* (page 106). How could *anyone* not adore these strange and beautiful creatures?

The very same might be said for Tim Hildebrandt's *Demon Swamp* (page 107), a page from a 1983 Tolkien-related calendar. The Hildebrandt brothers have frequently painted solo over their long career, and Tim's colourfully emotional style shines through this example of his art. The magic communicated in this painting is of a darker and more brooding sort.

Also dark in its psychological underpinnings but still visually appealing is Virgil Finlay's *Minimum Man* (facing page). This is a good example of the different effects some paintings have on different viewers. Some people look at this painting and think: Horror – little people with knives attacking this poor man! (If you classified the painting on the basis of the Andrew Marvel story it illustrated for *Famous Fantastic Magazine*, this would be the right conclusion.) But it is also an image that is simply

Tim White: ***The Courts of Chaos***
Cover for the novel by Roger Zelazny
(Avon, 1985)
Acrylics on illustration board
13in x 16in (33cm x 41cm)
*Reproduced by kind permission
of the artist.*

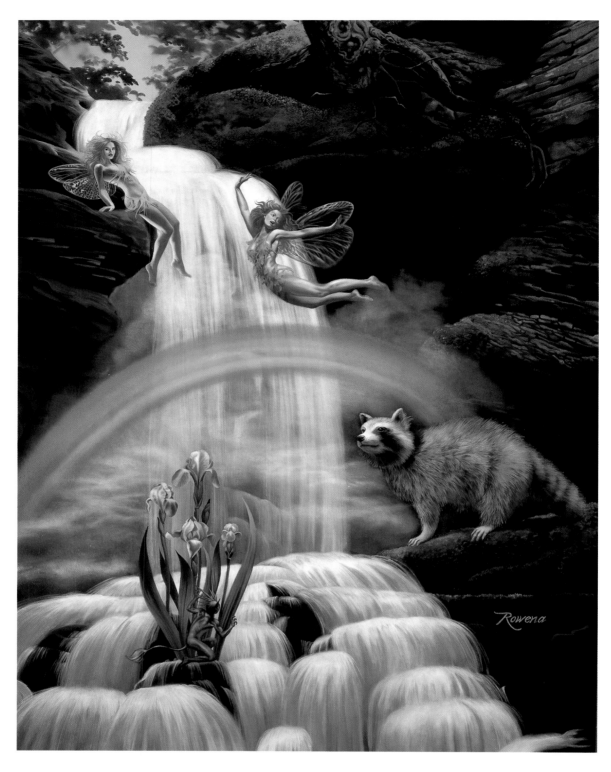

Rowena (Morrill): **Magic Racoon**
Interior illustration for *Martin Bear & Friends: Tales of Enchantment for the Child in All of Us* by Thomas Hauser (Hastings House, 1997; painted 1986)
Oils on masonite
26in x 20in (66cm x 51cm)
Reproduced by kind permission of the artist.

bold, provocative and colourful, and one that, perhaps most importantly, is interesting enough to grip your imagination. In other words, a magical painting of an imaginary place.

Because paintings with this kind of magic *can* transport you to unearthly places – some quite unappetizing and others wonderlands of pleasure, as in Rowena's *Magic Raccoon* (above).

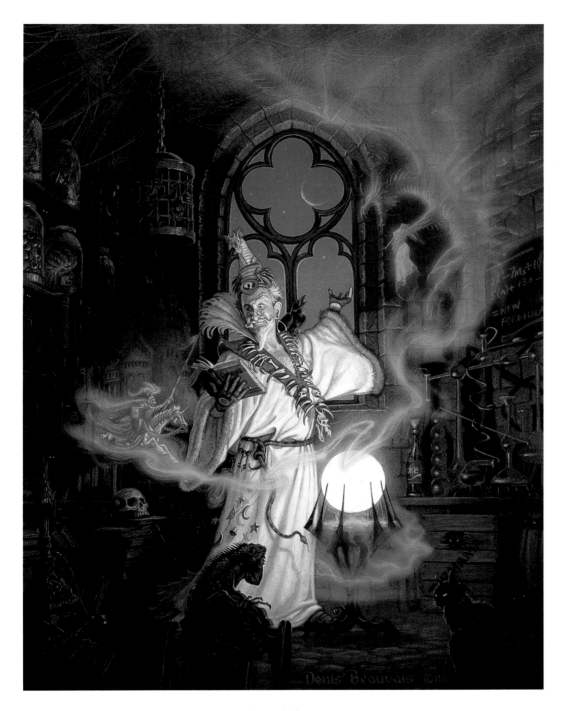

This painting is a delight to the eye and mind. It is interesting to see how the style of execution, 'hyper real', helps us to know that the scene is total fiction, while at the same time making it possible for us to imagine it!

The same precise technique can be found in Tim White's *The Courts of Chaos* (page 109), one of several book covers this artist produced for Roger Zelazny's popular *Amber* series. The colours in this painting are just plain sensational, almost psychedelic, and each dragon has its own personality! The carnage on the ground appears similarly colourful, as the beaten 'champions of the perfect realm' look up in astonishment.

Denis Beauvais: ***Spinning Tales***
Cover for *Dragon* (TSR™, 1985)
Acrylics on illustration board
20in x 15in (51cm x 38cm)
Reproduced by kind permission of the artist.
Copyright © by TSR™; reproduced by permission.

Thomas Canty: **Dandelion Wine**
Cover for the novel by Ray
Bradbury (Ballantine, 1990)
Watercolours and inks on
illustration board
14in x 22.5in (36cm x 57cm)
*Reproduced by kind permission
of the artist.*

A sense of wonder of an entirely different kind is found in Thomas Canty's *Dandelion Wine* (above). At first glance, Canty's painting seems to be merely a lovely pastoral American scene. This superficial impression does not last. Looking more closely at this disarming composition, we see that the mysterious upward wafting of the leaves provides a subtle clue that the painting is not telling us about the ordinary business of living but is, rather, communicating a magical sense of discovery and revelation. Canty's style is immediately identifiable; it is his unique 'visual signature' as much as his approach to the subject

matter that evokes the beauty of summer and childhood, tinged by nostalgia for a less complicated time and a sense of wonder.

We end this magical chapter with a work that cannot be taken for anything other than magical: Denis Beauvais's *Spinning Tales* (page 111). If ever there was a painting able to capture the whimsical delight of fantasy art, this is it. No need to probe one's subconscious for the meaning behind the art, no need to analyse its symbolism. There is a time and place for that, but not when the subject, *seriously* speaking, is magic.

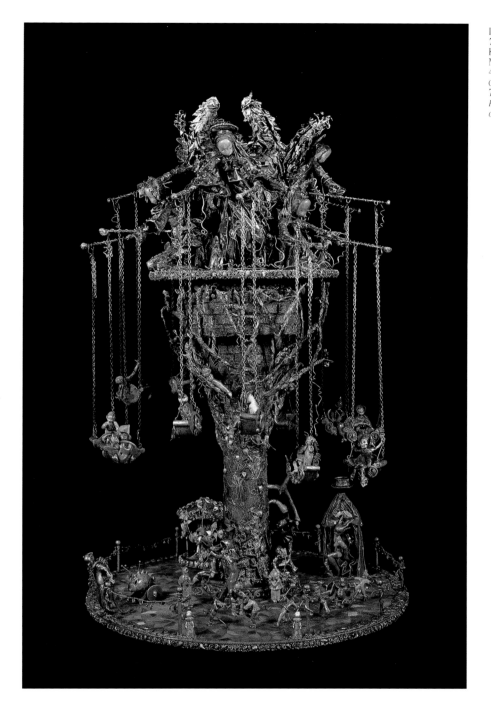

Lisa Snellings-Clark:
Turns at Cold Heaven Park
Kinetic sculpture, 2002
Mixed media
45in high x 28in wide x 28in
deep with 12 swings (114cm x
71cm x 71cm)
*Reproduced by kind permission
of the artist.*

Lisa worked non-stop throughout the convention talking with and answering questions from fans and fellow artists. Many more times than she can remember, she explained that

The ticket 'seller' wears dark glasses, not for the usual reason (to disguise where he's looking) but to disguise *that he's not looking at all* – at least, not with his eyes: his eyelids are sewn shut! For entrance into the carnival, he will accept payment of any object as long as it is very valuable to the person seeking entry. He is a powerful authority in the carnival, high up in the ranks, like a circus's ringmaster –

hence the tuxedo and top hat. He has the final say as to who gets in, much like the bouncer at an exclusive club, but this club is for keeps: you go in, you don't come out – or, at least, you don't come out the same person you were when you went in. It's *No Refunds, No Returns.*

By the end of the convention Lisa was both exhilarated and exhausted. 'People are always asking me about *The Dark Carnival*, and the characters that make up the series,' she says:

> Typically it happens like this: A visitor walks through the exhibit for a while, hands in pockets, going from sculpture to sculpture. He leans in to peer at some detail that catches his eye. Having discovered this tucked-away figure or bit of humour, he looks for more and finds they're everywhere. This may go on for ten minutes or an hour. He's fascinated, sort of, and disturbed, sort of. He may begin to enlist those around him, pointing here and there. Eventually, without fail, he will stop suddenly, make a beeline to me and demand to know *where this stuff comes from.*

Conceptualization remains a unique experience for Lisa. An idea comes from some experience, past or present, and she finds a way to represent it visually. The metaphor, the twists, and the play within the title develop gradually as she works: 'Angels, death, madness and isolation are ongoing themes, while harlequins, demons and rats laugh together at it all and ignorant humanity is sandwiched between.'

During the Millennium Worldcon convention in Philadelphia, Lisa showed us drawings for the next piece, *Turns at Cold Heaven Park* (pages 124 - 125). This is a flying swing ride with twelve swings and over fifty figures, including about three dozen rats and crows and several hundred tiny red roses. As has been the case for previous additions to the *Carnival*, we saw it for the first time in person at another convention, ConJose, the 60th World Science Fiction Convention, held in San Jose, CA, in 2002. It is another *coup* – another great contribution to *The Dark Carnival.*

When we initiated the *Dark Carnival* Project, we had no real conception of how gratifying the process would be. While Lisa is the artist, we feel like we, too, are part of the creation. Each piece is a fine work of art in its own right but, taken as a whole, the *Carnival* is, we believe, a truly great work and possibly even a masterpiece.

Three more years and the project will be complete. It will be sad for us to see it end. But at least the joy of its creation will continue until then.

INDEX OF ARTISTS AND WORKS